BREWING IN CHESHIRE

PAUL HURLEY

AMBERLEY

First published 2016

Amberley Publishing
The Hill, Stroud
Gloucestershire, GL5 4EP

www.amberley-books.com

Copyright © Paul Hurley, 2016
Maps contain Ornance Survey data.
Crown Copyright and database right, 2016

The right of Paul Hurley to be identified as
the Author of this work has been asserted in
accordance with the Copyrights, Designs and
Patents Act 1988.

ISBN 978 1 4456 5674 8 (print)
ISBN 978 1 4456 5675 5 (ebook)

British Library Cataloguing in Publication Data.
A catalogue record for this book is available from
the British Library.

Typesetting by Amberley Publishing.
Printed in the UK.

Contents

Acknowledgements

I would like to thank Chris Ward and Rona Woods from the Thomas Hardy Brewery; John Cole from Molson Coors Brewing Company (UK); Chris Stairmand from the Macclesfield and East Cheshire branch of CAMRA; Ian Bray from the South Cheshire branch of CAMRA; Gary Chester, from the North Cheshire branch of CAMRA, who is also Brewery Liaison Coordinator for Merseyside and Cheshire and whose input into the compilation of this book has been invaluable; George Symes, whose excellent magazine *Out in Cheshire* has been a font of valuable information; Linda Clark and Adam Shaw of the Chester Record Office; and most of the owners and managers of the breweries and microbreweries of Cheshire for their help and understanding.

Then there is the excellent work done by the Campaign for Real Ale (CAMRA) in promoting quality, choice and value of for money, and for promoting the brewers and the pubs they serve and helping consumers of traditional ales, ciders and perries to enjoy what is part of our national heritage and culture. Then, of course, my lovely wife Rose for her patience during the compilation of this book.

Introduction

Before we look at the breweries of Cheshire, both the ones currently brewing the golden nectar and the ones that have disappeared or been given a change of ownership, let's have a look at the brewing of beer from the early days. When tested, ancient pots recovered in Iran revealed traces of a beer-like substance dating back 7,000 years. This is the earliest indication that fermentation was known and used in those far-off days. Further evidence came to light when a 6,000-year-old Sumerian tablet was found depicting people drinking from a communal bowl with straws, and this was the oldest evidence of the drinking of beer. This is depicted on the Tatton Brewery logo, as you will see later in the book.

There was even a goddess of beer called Ninkasi, whose father was the King of Uruk, one of the most important cities in Mesopotamia. This ancient land, whose Greek name means 'between two rivers', covered Iraq and modern-day Syria and Turkey, but bordered other Middle Eastern countries. At the time of writing, this area is suffering death and destruction on an industrial scale but, in those very early days, it was known as the 'Cradle of Civilisation.' Not only did they give us beer but also the wheel – we have a lot to be grateful for. On another Sumerian tablet from this time is a 'hymn to Ninkasi', which, when translated, turned out to be a recipe for beer. It is in fact in the form of a poem and, dated to 1,800 BC, it explains that grain was converted to bread before fermentation, and that grapes as well as honey were added to the mix. This became a porridge-like gruel and it was drunk unfiltered, hence the need for straws. The University of Oxford, when translating the poem, describes combining bread for the yeast with malted and soaked grains, thereby fermenting the liquid in a vessel, and lastly filtering it.

Almost any cereal crop that contains sugar can be fermented. This reaction occurs spontaneously when it comes into contact with wild yeast in the air.

So, how do we make it in a manner that will suit the pallets of today? Beer is produced by steeping a starch source (the most common source is barley but other yeast grains can be used) in water and then adding brewer's yeast, which is basically a fungus, to the liquid for the fermenting process to begin. Hops are added to give the beer its flavour. Without going into too much detail, that is the basic method of beer manufacture.

Steps in the process of brewing beer are malting, milling, mashing, sparging, boiling, fermenting, conditioning, filtering and packaging. During this procedure, brewers will add their own ingredients in order to manufacture their own unique product.

From the pre-Roman days until water was reliably germ free around the beginning of the last century, beer has been a good substitute. In the Royal Navy prior to the twentieth century, water on long voyages would soon go off. Beer, on the other hand, would probably get better with age and because of its alcohol content would last longer. During this time sailors would be issued with weak beer; Nelson's flagship, HMS *Victory*, carried 50 tons of beer, and she had a complement of over 800 men who each received a daily ration of 8 pints. At this time, the Navy Victualling Board brewed its own beer in breweries situated in the naval victualling yards. On land in the Middle Ages, beer, usually of quite low strength, was the favoured drink of all classes from childhood onwards. Even nuns, according to a document from that time, were allowed 6 pints of beer a day. So, throughout the ages, beer or ale was a most popular drink and microbreweries of today would have felt quite at home, as that was the most popular form of brewery.

However, we have beer, ale, lager and porter – what is the difference? Time to seek the advice of CAMRA brewery liaison Coordinator Gary Chester, who helps us with the following explanation.

Beer is a drink made from malted barley, yeast, water and hops (although other ingredients are also used such as fruit and wheat, these four main ingredients are found in all beers). This includes lager.

Historically, ale traditionally referred to a lightly hopped beer, and the word 'beer' to a higher-hopped drink. Think of the phrases 'mild ale' and 'bitter beer' – typically mild was a low-hopped drink, and bitter had a much higher proportion of hops. 'Mild beer' or 'bitter ale' still feel wrong when you say them, although confusingly very highly hopped beers such as an IPA have the term 'ale' in their name (India Pale Ale).

Today, the key difference between ales and lagers is the type of fermentation. Fermentation is the process that turns the fermentable sugars in the malt into alcohol and carbon dioxide. Lagers are made using bottom-fermenting yeast, which sinks to the bottom of the fermenting vessel, and fermentation takes place at a relatively low temperature. Authentic lagers then undergo a long period of cooled conditioning in special tanks. Ales, which include bitters, milds, stouts, porters, barley wines, golden ales and old ales, use top-fermenting yeast. The yeast forms a thick head on the top of the fermenting vessel and the process is shorter, more vigorous and carried out at higher temperatures than lager. This is the traditional method of brewing British beer. I am grateful to Gary for his help with this explanation.

In London in the 1700s, an assorted range of beer was available and the customers would ask for a glass or tankard to be filled from the contents of about three barrels of different ales, in order to get the taste that they preferred. The ales would consist of old or 'stale' beer and new 'fresh' beer, and two types of brown ales. This was time consuming, and the Bell Brew House in Shoreditch saw an opening in the market; they experimented with having the popular dark ale available from one barrel. The new beer was known as 'Entire', because it was entirely from one cask. Brown malts were used, making the resulting beer dark, rich and thick, just as the customers wanted. It became

very popular with labourers and porters in London and, due to this, it was given the name 'Porter.' It was first brewed in 1722 and became one of the most popular beers in the city. Brewing porter made the large breweries more successful simply because of the mass market that they could cater for. It may have been slightly dearer to produce than light ales, as it had to stand for longer, but the large market that it attracted made up for this. All of the large breweries at the time brewed porter, including 'Stout Porter', which was a stronger version of porter. As time went on, this became known simply as 'stout,' and one brewery that still brews it today, offering the best example of stout, is Guinness.

True real ale aficionados have an interest as to whether the drink they are ordering is from a keg or a cask. This is a brief explanation: a misconception is that keg beer, unlike those in a cask, is filtered and pasteurised. However, according to CAMRA, this is untrue. The main difference is that cask ales are naturally carbonated, while keg beers have been made fizzy, usually by a mixture of carbon dioxide and nitrogen gas. After the initial fermentation, cask ales are put into casks along with a little sugar to keep the yeast going for a bit longer. Natural carbonation then occurs. Because of this, casks have to be stored at higher temperatures than kegs and the temperature of the cask ale is accordingly a little higher and the carbonation a little less than you get from keg beer. You can tell the difference for no other reason than the fact that keg beer is usually colder and more fizzy.

Back to Cheshire now, and we discover that the Great Fire of Nantwich, which started on 10 December 1583, destroyed most of the town. It burned for twenty days

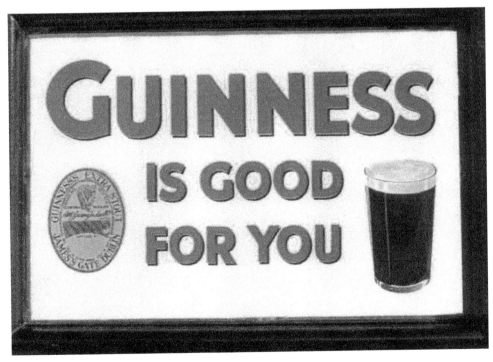

Guinness advert.

and destroyed 150 buildings, rendering half the population homeless. This was caused by a brewer; he carried out his brewing in the waterlode by the river, where he probably drew his water. The official cause of the fire was explained as '*through negligence of undiscrete [sic] persons brewing*'. A lot of the pubs trading in the Middle Ages brewed their own beer and sold it on the premises.

In today's licensing trade, it is apparent to all that the old-fashioned pub is 'wilting on the vine' in its popularity. Over the past ten years, pubs have been disappearing at a fast pace and the ones that continue to trade as ordinary, old-fashioned watering holes are leaving the scene. New and refurbished gastro pubs are taking their place and proving very popular, although there is still a requirement for a limited number of corner pubs stocking good ales, lagers and stout. Chains like Wetherspoons, with their low prices and deals offering good food with a drink, are proving popular.

What Wetherspoons are also famous for is their real ales from small microbreweries, which can be found in most non-franchised pubs and are very popular. In towns like Winsford a number of local pubs have been purchased by a company called Cornerstone Inns under local entrepreneur Damon Horrill. His relatively new company entered The National Publican Awards and was voted the Best Community Pub Operator in the UK in 2016. This company's pubs are obviously what people want. They have found an opening in a difficult market and taken up the challenge. This has resulted in the recent accolade. Similarly successful companies include Brunning & Price, with outlets throughout Cheshire, and Living Ventures, based in Knutsford with a raft of bars in Manchester and Cheshire.

As we will see, as the old brewers became part of large conglomerates, the call for good, old-fashioned real ale was still there. Although the large companies like Molson Coors provided a suitable and commendable real-ale product, many small start-up microbreweries came upon the scene to cater for a niche market. This they did well, and their popularity with beer drinkers became established. In this book, we look at both the large brewing companies and the small microbreweries whose products can be found nationwide.

The Old Breweries of Warrington

Let us have a look at the first of the old Cheshire breweries, the only large brewery still operating. Warrington and Chester were the homes of the main breweries in the county and at Burtonwood, between St Helens and Warrington, could be found the Burtonwood Brewery.

James Forshaw had some brewing experience when he worked at a brewery in Ormskirk, Lancashire, and, in 1867, with his wife Jane, purchased the land that was to become the Burtonwood Brewery. It was in a rural area with ample spring water for the manufacture of beer. The first brewery had an open-tiered copper, capable of brewing fourteen barrels, a twelve-barrel fermenting vessel and a cellar capacity

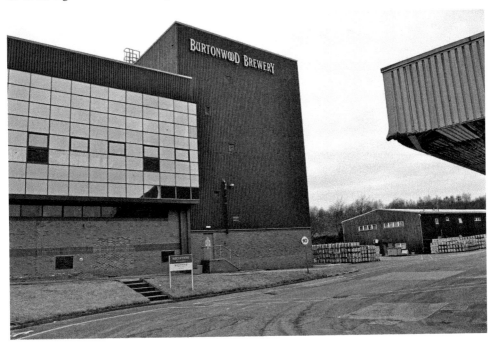

Molson Coors Brewery at Burtonwood.

Above: Burtonwood Brewery logo.

Left: Burtonwood Stout.

Forshaw's Burtonwood
pump label.

of forty-five barrels. Initially the trade was with free houses and private landowners, the beer being sold in small casks known as 'Tommy Thumpers'.

The company purchased their first freehold public house in 1874, and took out leases on a further eight other houses. In 1880, James died and the business was carried on by his widow Jane and her nephew Richard Forshaw, who was described in the company as a bookkeeper. In 1890 Jane remarried, to the vicar of Burtonwood, the Rev. William Wilson. Helped by a small legacy from his father, Richard Forshaw purchased the brewery from his aunt. In 1894 William Singleton joined the company as head brewer and, apart from short intervals, he and his son Harold were the head brewers until Harold's death in 1964. In 1895, under the direction of Richard, the brewery became one of the first local breweries to produce bottled beers, and these proved a great success. Then, by 1907, the brewery was producing some 200 barrels a week. By 1907, the internal combustion engine had arrived and the company became one of the first to acquire a motor lorry. It was a Pagefield make, manufactured by the Walker Brothers at Pagefield Iron Works in Wigan, Lancashire.

After the First World War, Richard (senior) and his eldest son Tom continued to expand the business in Lancashire and Cheshire, and his youngest son Richard formed the Burtonwood Engineering Co. in 1922. This is now a large motor group, the Dutton-Forshaw Motor Company Ltd.

In 1930 Richard died; Tom took over the brewing business and expanded it into North Wales, buying a further 100 public houses in the North Wales and Anglesey area. By 1949 the company was extremely successful and was renamed Burtonwood Brewery Co. (Forshaw's Ltd). In 1964 the company went public.

In 1986 to 1987 a modern distribution warehouse was built, together with a new kegging line. This was opened by Princess Margaret with the plaque unveiled as can be seen below.

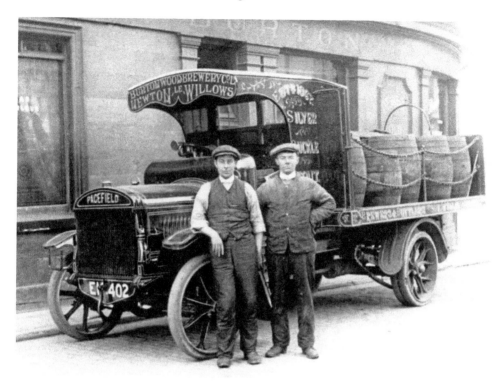

Pagefield Burtonwood lorry.

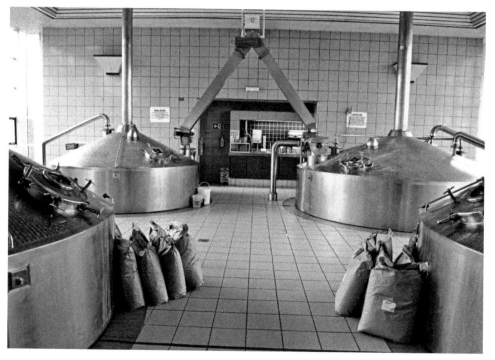

Molson Coors Brew house at Burtonwood.

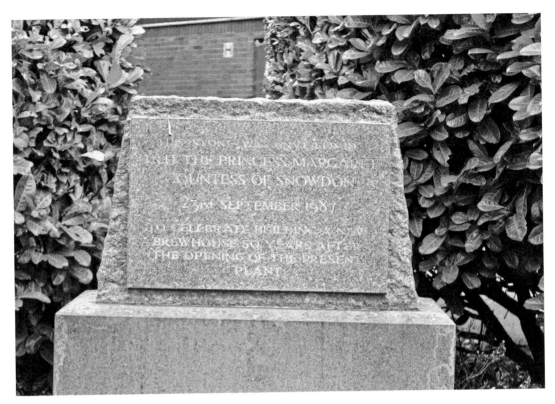

Princess Margaret plaque.

Between 1988 and 1989, Burtonwood Plc made major investments in the new brewery to upgrade the site, making it one of the most modern and technologically advanced medium-sized breweries in the country. It is worth noting here that the now-demolished Bridge Inn in Warrington held the world record for the longest pull of beer from the brewery to the bar in the pub, approximately one mile away.

In 1998 Thomas Hardy Holdings Ltd arrived, a contract brewing and packaging business originally established in 1997 out of the acquisition of Eldridge Pope Plc's production assets in Dorchester. They acquired the brewery and production facilities from Burtonwood Plc as part of its expansion in contract brewing and packaging, and thus Thomas Hardy Burtonwood Ltd was formed. Thomas Hardy Holdings Ltd acquired the entire site including the land from Burtonwood Plc in 2005 to supplement the bottling line they'd acquired from Usher of Trowbridge in 2002, and moved to Burtonwood.

In 2015 the site was split and the brewery, processing and kegging facilities were purchased by Molson Coors, leaving Thomas Hardy with their contract bottling business on the other half of the site.

The Molson Coors company is now one of the largest brewers in the world, with interests in Canada, the United States and Europe, together with Molson Coors International (MCI). They have a diverse portfolio of brands that they or their business partners own, and their signature beers are Coors Light, Molson Canadian,

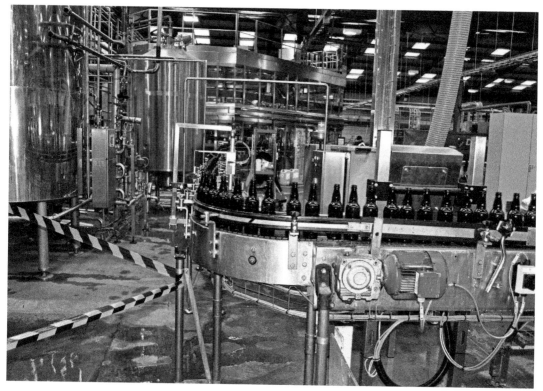

Thomas Hardy bottling line.

Molson Coors keg storage at Burtonwood.

Staropramen and Carling. The company has around 2,000 employees in the UK and Ireland, with breweries at Burton upon Trent, Tadcaster, Sharp's brewery in Rock, Cornwall, Franciscan Well in Cork, Ireland, and, of course, Burtonwood. The company has a share of around 20 per cent of the UK beer market, which includes Carling, the best-selling lager for thirty years. They also brew Cobra, Grolsch, Doom Bar, Worthington's, Caffrey's, Singha and a range of speciality beers.

The site is shared by Thomas Hardy Holdings and Molson Coors; however, it is the latter that now continues the tradition of brewing at this location. So, from 1867 to the present day, the village of Burtonwood has been a byword for excellent ales and stout.

Walkers Brewery Warrington

The second of our large breweries is Walkers Brewery in Warrington; it was built in the Dallam area in 1866 by Peter Walker and his son Andrew Barclay Walker, with the obvious name Peter Walker & Son. When production started, they had a capacity for 500 barrels a week but this soon increased to 10,000 barrels by 1890. As well as at Warrington, there were other branches at Burton upon Trent; this operated from 1890 to 1895, while the Shobnail brewery operated until 1923. In 1921 the company merged with Robert Cain, a Liverpool brewer, and an umbrella company was formed with the name Walker Cain Ltd. In 1923 all brewing was concentrated at Warrington under the Peter Walker name, and it was not until 1948 that the company became Peter Walker (Warrington) Ltd. Over this period a majority of Liverpool pubs carried the logo, as

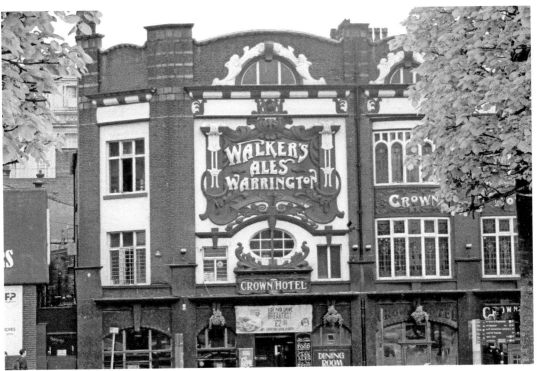

The Crown Hotel, Lime Street, Liverpool.

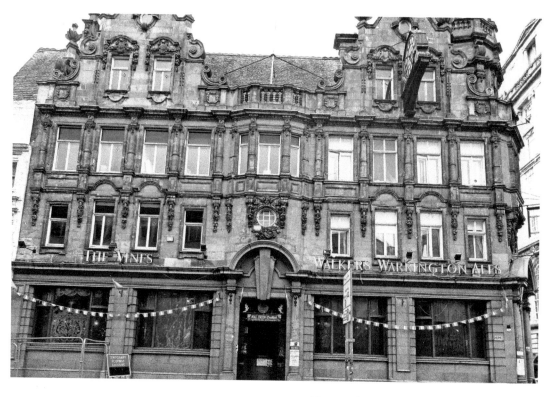

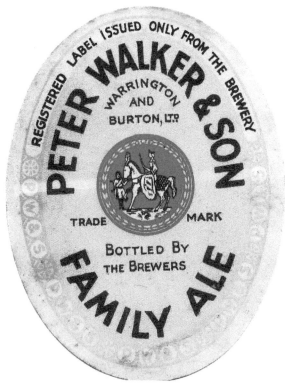

Above: The Vines, Lime Street, Liverpool.

Left: Walter's Family Ale.

seen in the photographs here; others had the large words 'Walkers (Warrington) Ales' around the building. Some were simply 'Walkers Ales' but, in the main, the name was writ large on most of their many public houses.

In 1960 the company became Tetley Walker after a merger with the Joshua Tetley company of Leeds and then from 1961 Allied Breweries. The name 'Peter Walker (Warrington) Ltd' was used for some time after this merger. The Dallam brewery closed in 1996 and the site was cleared. As for Allied Breweries, they became the largest brewers in Europe, if not the world. It all started in 1860 when Samuel Allsopp & Sons opened their business with the apt name The New Brewery, in Station Street, Burton upon Trent. The boast at the time by Henry Allsopp, who was the senior partner, was that his new brewery had a greater capacity than any single brewery in England. Over the next years the brewery went from strength to strength, but not without periods when they were close to bankruptcy.

In 1934 they merged with another Burton brewery, Ind Coope, taking with them six breweries that they had acquired over the years. Ind Coope had themselves taken over eight other breweries including Woolf's Ltd of Crewe, which they had acquired in 1923. This merger enabled the partners, Allsopp and Ind Coope, to continue with their acquisitions; these were mainly after the war, in 1945, when they purchased a further seven breweries, including in 1950 Lonsdale and Adshead of Macclesfield.

In 1959 the Allsopp name was dropped and, by the end of the 1950s, the Ind Coope company had acquired a huge estate of some 5,200 pubs. Their most famous brand at the time was Double Diamond with the well-known jingle, 'A Double Diamond works wonders, works wonders, works wonders, a Double Diamond works wonders, so drink one today.' By 1961 Edward Thompson was the chairman of Ind Coope and his already large conglomerate was joined by two of the ten largest brewers in the UK, namely Tetley Walker and Ansells. This made the new dynamic company the biggest brewer in the UK and, because of its assets in buildings and pubs, etc., the largest brewing group in the world at the time. The company had twelve breweries, 11 per cent of all of the UK's pubs, and supplied 48 per cent of total outlets including hotels, clubs and off licences.

In 1963 the name Allied Breweries was adopted to cover all of the business, and another two brewing companies were purchased. By the following year the company operated fourteen breweries, 125 hotels, 8,575 pubs and 1,780 off-licences. The company was now massive and initially successful but, in the late 1960s, they perhaps overstretched themselves by diversifying into acquiring cider and wine companies. Then in 1968 they acquired J. Lyons & Co., taking them into food, motor vehicles and meat products. In 1981, it was re-named Allied Lyons and then in 1994 Allied Domecq and by 1994 had become rather unwieldy, causing it to underperform and implode somewhat, leading to partial dismemberment. A 50 per cent stake in its breweries was sold to Carlsberg, leading to the name Carlsberg-Tetley and accordingly Carlsberg-Tetley Brewing Ltd inherited the breweries and the brands, and Punch Taverns the pubs.

This is just a brief look at what, after astute management, is now the massive worldwide conglomerate Allied-Lyons Plc. It has become one of the most important

The ex-brewery.

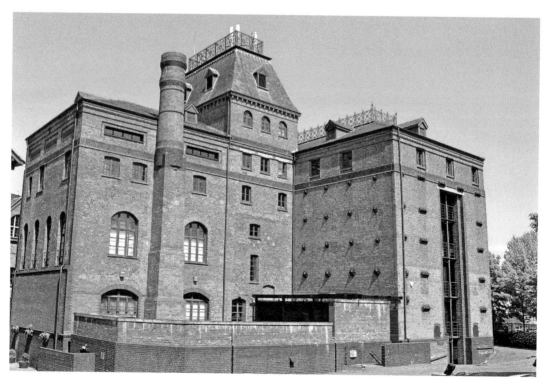

Brewery buildings.

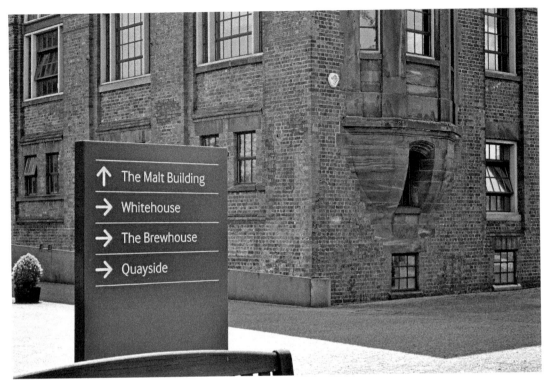

Above: Greenalls signpost.

Right: Greenalls plaque.

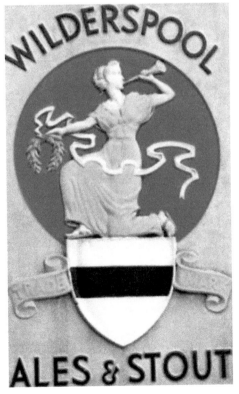

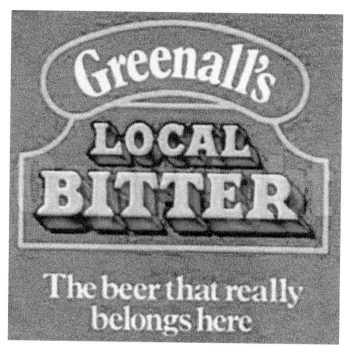

Greenalls Local Bitter.

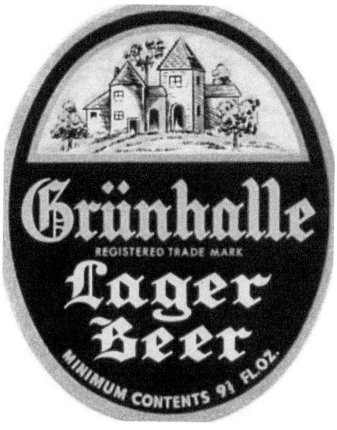

Grunhalle Lager Beer.

beverage companies in the world and the brewing arm produces such products as Skol, Tetley Bitter and Mild, Lowenbrau, Ansells bitter and mild and John Bull Bitter. One of those companies hidden away in the history of the group is Peter Walkers Brewery, Warrington.

Greenall Whitley

As can be seen here, over the years Warrington has been the hub of all things brewery: Burtonwood, Tetley-Walker and now Greenall Whitley. These were large breweries, whose businesses could be found across the country and further afield. Who can remember the television advert encouraging you to buy 'Vladivar Wodka from Varrington?' Vladivar was manufactured in Warrington by the G&J Greenall distillery. Today, however, it is made in Scotland by Whyte & Mackay Ltd, who purchased the brand in 1990. It's very difficult to say Vladivar from Scotland with the same strong Russian accent, so the advert lies only in the minds of those old enough to remember. The company of G&J Greenall is still going strong though and employs 100 people in Warrington, but as a distillery not as a brewer of fine beer. That honour goes to Greenall Whitley. Nevertheless, the family is connected.

In 1760 Thomas Dakin built a gin distillery in Bridge Street, Warrington, but, due to a lack of grain as the result of a poor harvest and a government insistence on all

From the last brew at Greenalls.

grain being used to make bread, the distillery did not open until the next year. The location was chosen because of the easy access to the river and canal. Dakin decided to make gin of a high quality, not the 'mother's ruin' depicted in Hogarth's then recent painting *Gin Lane*. Thomas died in the 1790s and his gin recipe was passed to his son William. Meanwhile, in nearby St Helen (which, like Warrington at the time, was in Lancashire) one Thomas Greenall was himself doing well with his brewery that had been established in 1762; he ran it with the help of his sons Edward, Peter and William Orrett. When William died in 1860, Edward Greenall leased and later bought Dakin's Bridge Street distillery.

Quite separately, however, the brewing arm of the Greenall family was prospering and Thomas Greenall built the business by acquiring other breweries and their tied pub estates. The company became known as Greenall Whitley and, by 1923, was one of the largest regional brewers in the country. The chairman was Lord Gilbert Greenall, 1st Baron Daresbury of Walton, who was ennobled by King George V in 1927. He decided to diversify the business by purchasing the distilling business of Gilbert & John Greenall, thereby uniting the two branches of the Greenall family. Travelling forward to 1961, Greenall Whitley had in its portfolio 1,200 pubs and the large Compass Hotels division, which they continued to increase with the purchase of the Groves and Whitnall brewery of Salford and, in 1978, Shipstone's brewery in Nottingham. Nine years later in 1986, Davenports brewery in Birmingham and the Wem brewery were brought into the chain.

They then closed all of these breweries in what some saw as a trail of destruction across the Midlands.

The company was still called Greenall Whitley & Co. Ltd, brewers of fine ales, but this stopped in 1991. The large brewing complex at Stockton Heath was sold to the property company Bruntwood, becoming the Wilderspool Business Park. It now houses apartments and offices. Greenall's concentrated on running hotels and pubs, with the title the 'De Vere Group'. In 2006 Lord Daresbury stood down as the non-executive chairman, thereby severing the family tie with the business. In September of that year the De Vere Group was sold to The Alternative Hotels Group PLC in a joint venture with HBOS. Alternative Hotels became the De Vere Group.

Bolton Brothers Brewery, 38 Mersey Street, Warrington
Was taken over by Greenall Whitley in November 1931.

Cunningham Brothers Ltd, Owen Street, Warrington
This company was founded as a wine and spirit merchants in the late 1800s and started brewing in 1909. They sold sixty-five licensed premises in 1951, of which thirty-four pubs and off licences were sold to Joshua Tetley & Sons. The brewery went under the name of B. Cunningham Ltd until June 6 1969, when they merged with Howcrofts Brewery in Bolton. The companies went into liquidation that year.

Breweries Closed and Operational in the Warrington Area

The Coach House Brewing Co., Wharf St, Howley, Warrington

Still in Warrington, we next find The Coach House Brewing Company. When Greenall Whitley ceased brewing, a number of their ex-employees got together and decided to put their expertise to good use by opening their own brewery. They took on a premises at Wharf Street, Howley, Warrington. The company was established in 1991 and the brewing of hand-crafted, cask-conditioned fine ales began. The company went from strength to strength and provided a regular supply of their products throughout the country. To this end, national and regional wholesale distributors were set up. The brewery has a fermentation capacity of 240 barrels; the company produces eleven permanent beers, seasonal beers and those brewed for special occasions. This includes an extensive range of fruit and spice beers.

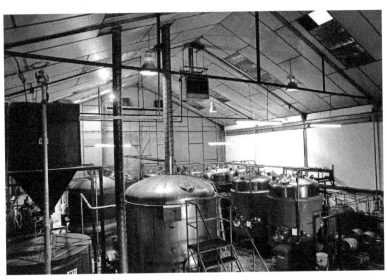

Brew house.

Ostlers.

Farriers.

Blueberry.

Gunpowder.

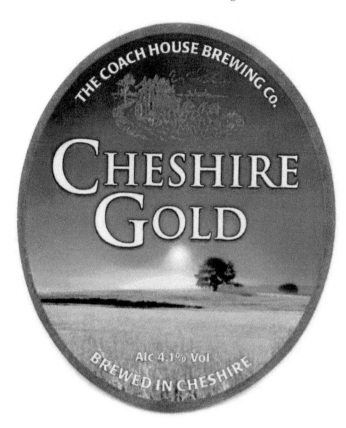

Cheshire Gold.

Coach House beers have enjoyed considerable success throughout the country; their regular brands are extensive and include Ostlers Summer Pale Ale with an ABV of 4.0 per cent, Farriers Classic Bitter with an ABV of 3.9 per cent. For a stronger bitter, there is Blueberry, a fruit bitter with an ABV 5.0 per cent, while Gunpowder is a premium mild ale with an ABV of 3.8 per cent and Cheshire Gold a pale, golden beer brewed entirely from malted Maris Otter barley, grown in Yorkshire, with an ABV of 4.1 per cent. These are just a few of this very popular brewery's products that can be found far and wide.

In all, around fifty-one different beers are available from this busy brewery and, as you will gather from this book, The Coach House Brewery is the longest-established small brewery still trading in Cheshire, with Molson Coors at Burtonwood being the largest.

4T's Brewery (The Tavern's Tasty Tipples)

Let's stay in Warrington for a visit to the next brewery. This time, it isn't one of the big concerns, but rather one that started its life in the Tavern pub at 25 Church St, Warrington. It was formally known as Wilkies Tavern after the owner John Wilkinson, who is still the owner. The pub also housed a microbrewery that was established there in 2010, although the pub started trading in 1999. John himself is the head brewer. He

had already brewed 350 beers in the Tavern premises and has now taken the business to another level. The brewing side of the business moved in 2012 to a unit on the Manor Industrial Estate on Lower Wash Lane, Warrington.

John carried on working alone and he never repeated a brew; each one was unique. By December of that year, demand was still growing and they had brewed forty-two brews on the kit once used by the Blueball Brewery. It was time to brew a core range of beers; these were titled Keep Calm, Wise and Stack, and the new range includes India Pale Ale at ABV 4.6 per cent, American Pale Ale with an ABV of 4 per cent, European Pale Ale with an ABV of 3.7 per cent and English Stout at 5.0 per cent.

John decided to take on an apprentice brewer and Jordan Millington, who had just turned twenty, joined the company. The plan was to turn Jordan into a first-rate brewer, and this came to fruition when his own brew, 'Not too Stout Bob,' reached the final of Champion Beer of Cheshire.

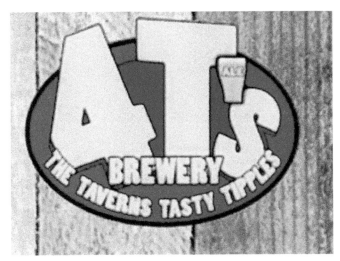

Right: 4T's logo.

Below: 4T's brewhouse.

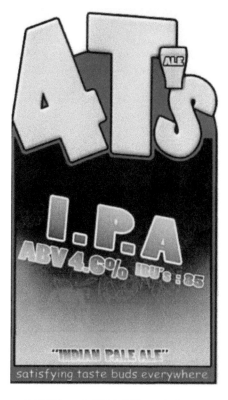

India Pale Ale.

American Pale Ale.

European Pale Ale.

English Stout.

Lymm Brewing Company Brewery Tap, Lymm

At one time it used to be Lymm post office in Bridgewater Street, Lymm, and then it became The Brewery Tap pub. The Dunham Massey Brewing Company is a small but successful family-run microbrewery located in Dunham Massey, Altrincham, Greater Manchester. This places it outside the scope of this book but some mention is needed. John Costello, an ex-Tetley Walker brewer, decided to set up a small brewery in a disused barn on National Trust land at Dunham Massey. John was passionate about beer, particularly real ale. On 1 August 2007 John and the family set about converting the barn into a brewery and, soon after, brewing started. They brewed ale for their two outlets: Costello's in Stockton Heath and Costello's in Altrincham. Other businesses, such as various pubs and clubs, also served Dunham Massey ale.

Back now to the Lymm Brewery, by August 2013 the Dunham Massey brewery had reached capacity and another microbrewery was set up under the Brewery Tap in

Lymm Brewing logo.

Heritage Trail Ale.

Lymm. Although part of the Dunham Massey brewery, it was operated independently with regard to the brewing and the end product sold through Dunham Massey. Lymm produce beer of the same high standard and their most successful beer is Bridgewater Blonde, a blonde beer with an ABV of 4.0 per cent. Other Lymm brewery beers are Lymm Dam Strong Ale with an ABV of 7.2 per cent, Slitten Brook Stout with an ABV of 4.0 per cent, and their extra-strong beer Heritage Trail Ale, with an ABV of 4.5 per cent. Naturally, all of their ales are sold upstairs in The Brewery Tap, but their word-of-mouth popularity is growing, leading to their products being sold to other outlets across the North West. They say that they brew quality English beers using only English malts and hops and with no added sugars.

Lymm Brewery Slitten
Brook Stout.

Lymm Brewery Amber
Session Bitter.

Breweries Closed and Operational in Central and North Cheshire

Weetwood Ales, The Brewery Common Lane, Kelsall

One of the best known of Cheshire's breweries is Weetwood Ales. The company was established in 1992 by Adrian Slater and Robert Langford in a barn on Roger's farm in the village of Weetwood, near Tarporley. They saw that, with the demise of large breweries, there would be demand for traditional British cask ale, and decided to get involved. The first beers that they brewed were on a five-barrel plant, and they were

Weetwood van.

very well received by beer lovers in local pubs. Weetwood's reputation for first-class ale was soon assured.

The brands went from strength to strength in popularity, and soon more brewing capacity was required. With extra staff employed and more outlets selling the product, interest in the beer literally exploded. Accordingly, in 2012 a much bigger site was required and a new thirty-barrel brewery was built on a new site nearby at Common Lane Kelsall. The demand for its beer continued to grow and, in the new brewery, they could meet this demand and have space to expand.

In 2014, the original founders, Adrian and Robert, took a step back, although they continued to be involved, and the new owners Phil McLaughlin and Laura Humby arrived. Phil and Laura, a family team, brought passion, experience and enthusiasm to what was already a very successful operation.

Weetwood ales are delivered by their own drivers to hundreds of customers in the North-West and North Wales each week. Their brands include Cheshire Cat, a blonde ale with an ABV of 4.0 per cent; Weetwood Bitter, the first ale brewed in the new brewery and still a favourite with an ABV of 3.8 per cent; Eastgate, an award-winning ale brewed as a tribute to the famous Chester Clock with an ABV of 4.2 per cent; then there is Old Dog at 4.5 per cent ABV, a premium bitter that is dark, smooth and full bodied; finally, we have Southern Cross, which, with an ABV of 3.6 per cent, is classed as a New World pale ale.

Sandiway Ales, Blakemere Village, Chester Roadd, Northwich

In January 2016, this modern microbrewery was set up by father-and-son team Mike and Paul Hill, with twelve years' brewing experience between them. This new brewery has hit the ground running and already has a reputation for quality ales.

They have four cask ales available: Hop Secret, a deep dark porter with a hint of coffee and an ABV of 4.5 per cent; Hop Salvo, a pale session bitter with citrus flavours and an ABV of 3.8 per cent; Hop Sepia, a traditional copper bitter with caramel and liquorice and an ABV of 4.3 per cent; and Hop Schism, a golden ale with an ABV of 4.1 per cent.

Customers for their products can be found around Cheshire, with a radius as far afield as Liverpool. Visitors to the popular Blakemere Craft Centre are invited to visit the micro-pub next to the brewery, which is called 'The Wee Howff', where two cask ales, bottled beers, ciders and wines can be enjoyed. I have to add here that Mike also owns our favourite pub, the No. 4 Bar at Over Square in Winsford – I suppose you would call it our local. For those with an interest in brewing, there are tours of the brewery and lessons in brewing. Vouchers can be bought as birthday presents for those interested.

A new brewery, but one to watch.

Tatton Brewery, Knutsford

This family-run brewery was established in 2010, and has built up an impressive reputation from the onset. The brew house is custom built with modern equipment, and the finest ingredients are used, combining good old-fashioned classic and contemporary beer with an up-to-date work ethic. Gregg Sawyer is the owner and head brewer with a wealth of experience, while his two assistants are Andrew Last and Lee Gannon.

Right: Tatton Brewery logo.

Below: Brewhouse.

Tatton Brewery Blonde.

Tatton Gold.

Tatton Ale.

Tatton Best.

Tatton beers are available for home consumption in mini pins, cask and bottles, while their products are available at pubs, restaurants and clubs throughout the North West. They ensure that every pint they sell should be as good as the last one.

The company logo seen above originates from ancient Mesopotamia, which was the birthplace of brewing. It is a 4,000-year-old trader's seal depicting two people enjoying a drink together as they did in those far off days, using one drinking vessel and two straws. It fits in nicely with the company ethos that 'good beer is a social pleasure to be shared with good friends'.

To list a few of their beers: Tatton Brewery Ale has an ABV of 3.7 per cent and is an easy drinking session ale ('Tatton Brewery' precedes all of the names); Blonde has an ABV of 4.0 per cent and is a blonde beer, with a hoppy fruity taste and aroma; with an ABV of 4.2 per cent, Best has a clean malt flavour and hoppy character; Gold is a little stronger at 4.8 per cent ABV, with a generous maltiness backed up with a robust hop character. Accompanying these beers, the company brews several seasonal and occasional beers. Situated at the Longridge Trading estate in Knutsford, the brewery welcomes pre-booked brewery tours.

The company has a portfolio of successes in beer festivals and the like. In August 2010, when quite new to the scene, they entered Tatton Brewery Best in the first ever Cheshire Country Fair Real Ale competition. Ten Cheshire breweries submitted beers that were judged by the public in a blind scoring of aroma, appearance and taste. Tatton Brewery won best beer in the competition. The following month they came joint second in the Champion Beer of Cheshire at the Northwich Beer Festival and also won Beer of the Festival. This theme continued in the following years, with too many awards, in fact, to include here but an impressive tally.

Sandifords Brewery, Witton Street, Northwich

In 1880 James Hampson was a wholesale brewer with his brewery in Witton Street; another brewer in the same street was the company of Nash and Skidmore. By 1896 they had both gone and the premises of James Hampson was purchased

The brewery.

Bass & Co. Pale Ale bottled
by Sandifords.

by N. P. Sandiford and Son, which to remain there until the 1970s. Their main business was the manufacture of mineral waters and the sale of wines and spirits. They also bottled and sold beer for other breweries, in particular the Bass company in Burton upon Trent. The company also had a branch in Manchester. Sandifords were well known in Northwich; from opening in 1896, their stone and glass 'pop' bottles were delivered to the door.

Britman Craft Beers, Burton Manor, Burton, Neston.

Situated in the beautiful grounds of Burton Manor, a stately home in Burton, we find the Britman Craft Beer Microbrewery occupying the 200-year-old, Grade II listed stable block. Les Ward spent time in Germany and, like a lot of people, enjoyed the quality of German beer. He decided with his partner Julie Perkins to have a life change and start brewing high-quality beer himself. Beer with no additives or accelerants, no added brewing sugar or chemicals – just beer brewed slowly and carefully to the highest quality.

In 2012 he leased the stable block of the manor, which is now under the control of Chester University. He then built a microbrewery to his own exacting requirements. Britman Brewery produces all its beer styles using only malted barley grain, hops, yeast and water, and Les believes that the time-honoured way is the only way. They have an efficient and effective craft brewing process that produces a range

of premium-quality beer in bottle, cask and keg. This includes Golden Ale with an ABV of 4.6 per cent, London Porter, with an ABV of 4.5 per cent, and, with an ABV of 4.4 per cent, Best Bitter.

There is no hard sell, just visits to farmers' markets and beer festivals, etc., and through this the customer base is steadily growing by word of mouth, making their products increasingly desirable to lovers of Real Craft Ale.

Norton Brewing Norton Priory at Runcorn

Norton Brewing is a social enterprise brewery in the ground of Norton Priory. It comes under the auspices of Halton Community Services, where employment opportunities are provided for people with learning difficulties and vulnerable adults. Their products are sold at Norton Priory, craft markets and selected pubs. Plans are afoot to also sell their products in the Strangers' Bar in the House of Commons.

The current brews are: Priory Ale with a 4.2 per cent ABV, described as an amber-coloured ale; Priory Gold, a smooth golden ale with a hint of orange and an ABV of 4.2; and Priory Velvet, a smooth dark ruby ale, with a hint of chocolate and an ABV, like the other two, of 4.2. per cent Their beers can be purchased in bottles, three-bottle gift sets, 5-litre mini kegs and 10-gallon casks.

Over Brewery, Over, Winsford

Owned by John Crompton Armitage and sold in 1908 with two public houses.

Navigation Brewery, Canal Street, Runcorn

Owned by Thomas Jones, it ceased brewing in 1906.

Britman Brewery.

Breweries Closed and Operational in and Around Chester

Deva Craft Beer, Babbage Rd, Sandicroft
This is another brewery that originated in Chester; but it is now a mile or so down the road in Sandicroft, just over the Cheshire border. 'Deva' is an ancient name for Chester

Deva Pandemonium.

Deva Nemesis.

Deva Experimentium.

Deva Equinox.

Deva Dual IPA.

Cellars Summer Pale

Deva Cellarium.

and the brewery of that name was set up in August 2014 by father-and-son team Adie and Nick Gilbody. After retiring as a systems engineer for a large US company, Adie decided on a complete change and his son Nick joined him in this new enterprise. Nick has had several jobs, ranging from science teacher to HR administrator to even trained hypnotherapist; however, when the opportunity to start up a commercial brewery appeared, they both leapt at the chance. Going from a 30-litre home brew to over 800 litres per brew was an exciting challenge.

The new brewery in Unit 14 at the Engineer Park in Sandycroft is now turning out numerous brews of well-received beer, while more are currently under development. In 2015 the team welcomed a new member, Tom Sinclair, an award-winning brewer who has brought his own brand of flair and enthusiasm to the business. They have, probably, the most vibrant of all bottle labels, examples of which are shown here.

Their stable of beers includes an American pale ale called Pandemonium at ABV 5.5 per cent, and a heavily hopped beer with an ABV of 4.0 per cent called Nemesis. There is also Experimentium I, with 4.0 per cent ABV. These are just a few examples of the bottle and keg beers that are available.

They have recently been awarded the accolade of Best Local Brewery at the Chester Beer Awards in February of this year. The Deva Craft Beer brewery now supply their products to pubs, clubs and restaurants over a wide area including North Wales, The Wirral, Macclesfield and South Cheshire.

The Beer Refinery Wervin, Nr Chester

In 2014 a group of friends got together to share anecdotes in regard to their hobby of home brewing. All worked full time and decided to have a go at brewing on a larger scale, pooling their knowledge of the subject; individually they were all getting good results, so it made sense to combine this expertise. Accordingly, they became investors and employees, and then in March 2014 the new microbrewery was planned. Work started on what was originally called the 'Born in a Brewery' brewery! It was based in the Chapel Court Enterprise Centre in Wervin, between Chester and Ellesmere Port. By September of that year it was time to start brewing and, for that matter, to change the name. The brewery overlooks the big Stanlow Oil Refinery, so a link to it was chosen and the name was changed to 'The Beer Refinery' (although the trade name is still Born in a Brewery LTD). It was started with the ten shareholders, who also shared the work in the Brewhouse.

The brewery is small and only produces approximately ten firkins per month. All of the members do it as a hobby, and any profit they make goes back into buying equipment. They still have full-time jobs to keep the wolf from the door, and take time to get their brews right. On occasions they brew for other brewers. Already they supply

Beer Refinery logo.

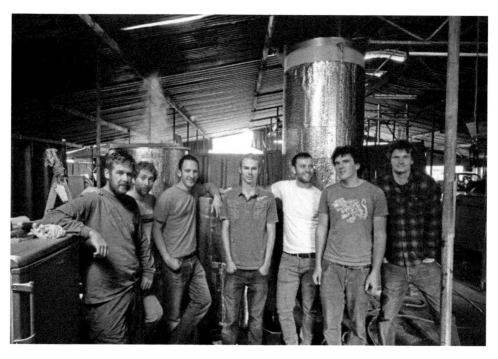

Above: The Beer Refinery staff.

Left: Crude Ale.

Beer refinery Peninsula ESB.

some well-known pubs in Chester such as Kash, The Architect, Telfords, Artichoke, The Cross Keys and The Cellar, to name but a few on a list that is growing as their quality brews become known. They started with two regular brews: Mischief, a pale ale with an ABV of 4.6 per cent and brewed with English hops; and West Coast Pale, the same brew but with American Hops. However, as brewing is a hobby and fun, they do not want to just brew the same ale every month so something new is provided. Although the brews change on a regular basis, others include Patent Penguin, a porter with an ABV of 4.5 per cent, Crude Ale with an ABV of 4.0 per cent, and finally Peninsula ESB with an ABV of 5.5 per cent. Another small brewery that is giving the real-ale aficionados a well-brewed, quality product.

Spitting Feathers Brewery, Common Farm, Waverton Chester
In Spring 2005, Mathew Walley cashed in his pension and blew the lot on brewing equipment. He told no one other than his good friend Terry Ashford, who joined him in the conspiracy to brew beer of the best. The first brew they called 'Old Wavertonian' and they entered it in the CAMRA Northwich Beer Festival in 2005.

They won Beer of the Festival, and so they decided that what they were doing was working. The first beer in the first beer festival and they won it! From then on, it was onwards and upwards. Three years later, they opened their first pub and what a pub! The Brewery Tap in Lower Bridge Street, Chester, the old Jacobean house built for the Gamul family, containing the only stone-built medieval hall in Chester, which now serves as the bar. The fireplace behind the bar dates from the early sixteenth century.

It was the house that Charles I stayed at on the night before his troops were routed in the battle of Rowton Moor or Rowton Heath, leading to his downfall. Now the Spitting Feathers brewery is near the site of the battle at Common Farm, Waverton. The Brewery Tap has since cleared the boards in most local and regional pub awards. In 2014 they added a pub in West Kirkby to the portfolio, with the name the West Kirkby Tap.

As well as supplying their own two outlets, other pubs and clubs are supplied with their products. As for the brewery itself, grains from the farm are used in the brewing, and the resulting mash is fed to the cattle and pigs on the farm. The meat from these well-cared-for animals supplies their two pubs and further afield. Honey from their bee hives provide the ingredients for some of their beers and they even grow some hops for use in occasional or special brews. The three main beers are Repetitive Strain Injury, a refreshingly strong beer with an ABV of 5.6 per cent; Special Ale, a malty, chestnut-brown beer with an ABV of 4.2 per cent; Session Beer, a golden session beer with an ABV of 3.6 per cent; Brainstorm, a robust ale with an ABV of 4.0 per cent; and, finally, NSFW, a strong beer full of smooth flavours with an ABV of 7.5 per cent.

Keeping the traditions of old, they brew a selection of Heritage Ales. The first is Victorian Porter; an authentic recipe from 1865 is used for this porter.

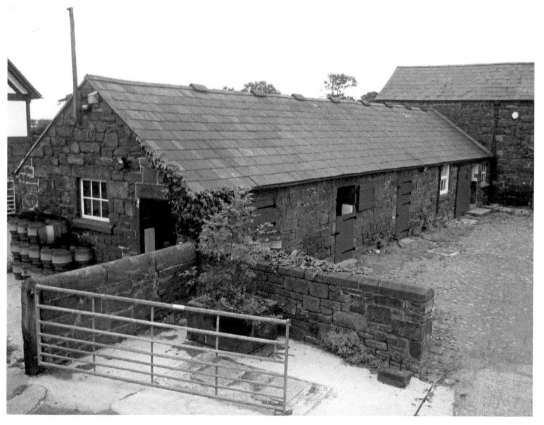

The brewery.

Logo.

Repetitive strain injury.

Brainstorm.

NSFW.

Special Ale.

Revolution is a pale beer that led to the growth of the large-scale brewing of pale beer. Northgate Ale is also brewed from an old recipe from the archives of the old Northgate Brewery, bringing a typical Chester brew back to the market. From even further back, Roman Ale is brewed after analysing the residue from Roman pots discovered during archaeological digs, while Empire IPA was brewed during the period of the Raj in India. It was stronger and brewed specifically to be conveyed across the world without spoiling. All of these heritage ales are available at different times of the year.

There are regular day and evening brewery tours and a charity beer festival in the summer.

The Pied Bull at Chester

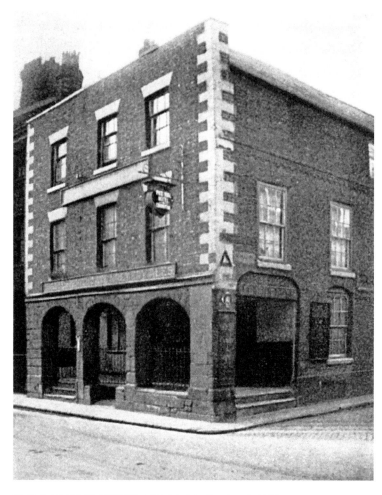

Pied Bull Hotel,
early 1900s.

Pied Bull Brew
House.

Pied Bull beers.

Just by the famous Chester walls can be found the only microbrewery within the walls – and what a successful one it is. The Pied Bull, probably the oldest continuously licensed pub in Chester, was built sometime within the thirteenth century as a mansion house, going by the name of Bull Mansion. It has a handmade staircase dating back to 1533, when it was rebuilt to become the home of the Recorder of Chester. Around twenty years later, it became an inn and was called The Bull Inn, reflecting the existence of the cattle or beast market outside the nearby Northgate. This name was later changed to The Pied Bull, and it became one of Chester's important coaching inns. The microbrewery within the pub was established in 2011 and the ale brewed there soon became well known and sought after. It is the only microbrewery within the city walls; sold on the premises and to customers far and wide are such brands as Sitting Bull, Sensibull, Gullabull, Black Bull, Matador and Pied Eyed – there is a theme here!

In 2012 the CAMRA Champion Beer of Cheshire was Matador and then in 2015 the CAMRA Champion Beer of the North West was Black Bull Porter. Real ale lovers can also take advantage of the bedrooms that are available, some of them boasting their own ghost!

Northgate Brewery, Old Chester

Now we are in Chester, where another of the large Cheshire breweries was situated just around the corner from the Pied Bull. That was the Northgate Brewery; this famous Chester Brewery finally closed its door in 1969. The Northgate Brewery was founded in 1760 at the Golden Falcon Inn. This inn stood close to the Northgate, and it was first recorded in 1704. For many years it was considered the principal coaching inn of the city but, by 1782, it had become a doctor's surgery. A new brewery complex was built on the site in the 1850s and the Chester Northgate Brewery Co. Ltd was registered in March 1885 as a limited liability. The company acquired Salmon & Co., wine and spirit merchants of Chester in 1890 and the Kelsterton Brewery Co. Ltd, Kelsterton, Clwyd, with ninety-three licensed houses, in 1899.

By 1891, the company owned twenty-one tied houses in Chester and numerous others within a radius of 15 miles from the city. It was the only Chester brewery to survive beyond 1914. In its turn, it was acquired by Greenall Whitley & Co. Ltd in 1949 with about 140 tied houses. Brewing ceased in 1969 and it was demolished in 1971.

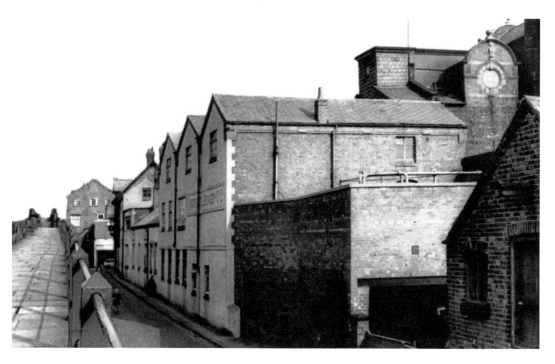

Above: The brewery.

Left: Northgate logo.

Northgate All Clear.

Northgate Milk Stout.

Cheshire Brew Brothers, Unit 6 Stanney Mill, Dutton, Chester

One night, two best mates were in a small crowded bar in the beautiful Belgian city of Bruges. As they sipped their excellent Belgian beer, the conversation got around to the idea of making quality beer in the UK. They continued to enjoy the Belgian beer and the Brew Brothers was born. All that was left was to return home and to start to put the dream into practice. Although they had decided on the name The Brew Brothers, they completed the triumvirate of brothers by recruiting another friend called Sean in January 2015, with the intention of teaching him the business.

In 2013 they had built a brewery in Stanney Mill Industrial Estate, Dutton Green, near Chester, and they started brewing. The friends and their rather strangely named Cheshire Brew Brothers brewery had a passion for great beer, and this they worked hard to perfect. Being friends meant that their hard work would be rewarded by the enjoyment of each other's company, with plenty of laughs and fun along the way, all

Above: Brew Brothers logo.

Left: Chester Gold CBB.

Earl's Eye Amber CBB.

Roodee Dark CBB.

Cheshire Best Bitter CBB.

with a great sense of pride. Their pride in the quality of the beer that they were brewing was amply evidenced in 2015, when RateBeer.Com declared that they were the best new brewery in Cheshire in that year.

Their first brew was Chester Gold, a pale brew with an ABV of 3.6 per cent, which is still a favourite. This was followed by Earl's Eye Amber, named after a bend in the River Dee upon which Chester stands; this amber ale has an ABV of 3.8 per cent. Then there is Roodee Dark, named after Chester's famous and ancient racecourse, a darker beer with a hint of roasted coffee and chocolate, with an ABV of 4.5 per cent. Finally, there is Cheshire Best Bitter, a full-strength traditional English ale with an ABV of 4.5 per cent. It is expensive to brew but well worth it. What started as a chat in a Belgian pub has metamorphosed into a successful microbrewery with an excellent choice of real ales.

The Lion Brewery in Chester

Looking now at another long-defunct brewery, the Lion Brewery was once located where the multi-storey car park in Pepper St, Chester, now is. The brewery was owned and run by the Whittle family and by 1846 the business was known as Whittle & Jones. In 1873 the brewery was sold to two partners called Walton and Clare but they later sold it. It was purchased by Bents Brewery in 1902 and closed soon after. The stone lion statue from the top of the brewery can still be seen on the top of the car park.

The Albion Brewery, Foregate St, Chester

This brewery owned a great number of city-centre pubs. The brewery served the people of Chester from the seventeenth to the twentieth century, mainly owned by the Seller family. It closed in 1919.

Mollington Brewery, near Chester

Owned by G. Williamson and sold by auction on 11 May 1912 to Thomas Crump of Chester for £1,250.

Joseph Salmon Brewery, Farndon, Chester

Was taken over by the Chester Lion Brewery in 1898.

Breweries Closed and Operational in and Around Macclesfield

Happy Valley Brewery, Bollington

The Happy Valley Brewery was established in 2010 by David and Nicola Hughes, and is situated in Bollington, near Macclesfield. Prior to setting up the new business, David had over twenty years' brewing experience and used this experience to install a purpose-built and modern microbrewery. The aim was to produce a range of traditional real ales using their own Lancashire mill town brewery yeast. When the work of setting up the new brewery was complete, it was time to brew their first ale. This was called Sworn Secret and this new-to-the-market real ale soon won accolades. It won a gold

Happy Valley logo.

Sworn Secret.

Black Out XO.

medal for being the Best Overall Beer at the Stockport Beer Festival in 2011. This was followed by Lazy Daze and Black Magic, which won silver medals in the Champion Beer of Cheshire in 2011.

Their beer is advertised as being made with the freshest ingredients, sourced locally where possible, and a selection of their other ales include the strong Sworn Secret, a pale, straw-coloured ale with an ABV of 3.8 per cent, and Five Rings, a light-coloured ale and an excellent summer-session ale with an ABV of 4.0 per cent. Another strong beer is Dangerously Dark, a black American IPA with an ABV of 5.6 per cent. And, of course, there is Black Out XO, Champion Beer of Cheshire in 2013, a dark, full-bodied rum porter with an ABV of 4.4 per cent.

Many of their ales can be obtained in bottles and can be found at various outlets in Cheshire Derbyshire, Staffordshire, Manchester and North Wales. Special beers are brewed especially, for instance, for such outlets as the Electric Bar, Chorlton, in Manchester. Bright Spark, with an ABV of 3.7 per cent, Black Out XO and Live Wire IPA, with an ABV of 5.0 per cent. Then there is the Egerton Arms at Chelford, Lord Maurice at 3.8 per cent ABV. At the Royal Hotel Hayfield can be found Kinder Falldown at 3.8 per cent ABV.

Bollington Brewing Company, Adlington Road, Bollington.

The village of Bollington, near Macclesfield, is set in the beautiful Cheshire countryside, and it has always been a village with a good selection of pubs. It has not, however, had

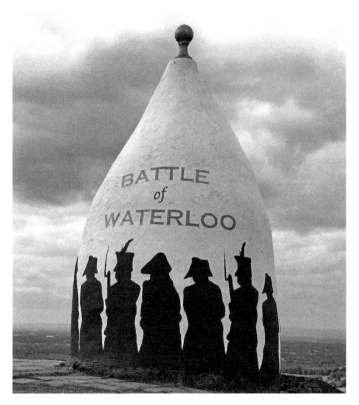

White Nancy.

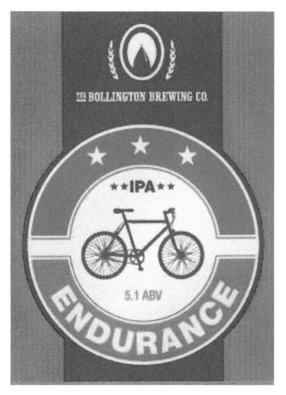

Endurance.

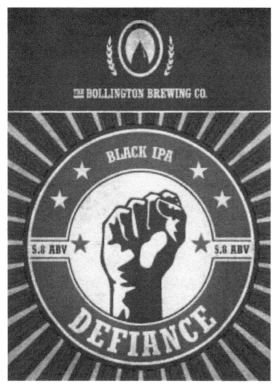

Defiance.

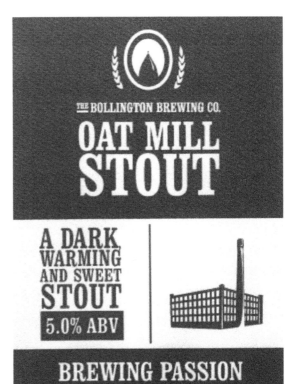

Oat Mill stout.

White Nancy.

Goldenthal.

a brewery for seventy years, the last one being the Heavers Brothers brewery. In 2008 it was time to renew Bollington's acquaintance with the brewing of the amber nectar, and the newly formed Bollington Brewing Company opened its doors and brewed its first brew, aptly named what else but 'First Brew'. This soon changed to 'Bollington Best', due to the success and taste of that first attempt – it is still their most successful brew. They have their own pubs from which their products can be enjoyed: they are The Vale Inn, Bollington (which is now a free house), The Park Tavern, Macclesfield, and the Cask Tavern at Poynton. Other pubs in the area stock their products; in fact, because of the popularity of their product with wholesalers, their beer can now be found in pubs across all of the North West and as far afield as London and Scotland.

In 2009, under their head brewer Kym Wainwright, they were awarded a gold medal for Bollington Best and a silver medal for Oat Mill Stout in the CAMRA Champion Beer of Cheshire. The same year, they entered the Sheffield Steel City Beer Festival and won in the gold category for Bollington Nights and White Nancy, and then overall second for Bollington Nights and third place for White Nancy. In the CAMRA Champion Beer of Britain, they were awarded bronze in the Best Bitter category for Bollington Best.

Their products include in keg, Endurance, a beer that was designed in collaboration with Glyn Fisher, who completed a coast-to-coast charity bike ride for Macmillan. A bike is pictured on the label of this IPA, brewed with Citra hops and Mangrove Jack US west-coast yeast. It has an ABV of 5.1 per cent. There was also the keg beer

Defiance, a jet-black IPA with fruit flavours and aromas. It has an ABV of 5.8 per cent. Another medal winner was Oat Meal Stout, a dark beer with a hoppy bitter taste and an ABV of 5.0 per cent. White Nancy, named after the folly celebrating the Battle of Waterloo that sits above Bollington (a photograph can be seen above), is a pale-coloured best bitter with lots of body and an ABV of 4.1 per cent. Finally is a strong bottled beer called Goldenthal, named after a nearby mill with that name, which in German means 'happy valley'. With an ABV of 7.4 per cent, this barley wine is not for the faint hearted.

Mobberley Fine Ales, Dairy Farm, Church Lane Mobberley

The company was set up in 2011, and started brewing traditional beers including Hedge Hopper, Road Runner and Whirly Bird, all of which are still brewed today. In December 2012 the company went into first gear: they moved to larger premises, Dairy Farm in Church Lane, Mobberley, and in doing so had more room to work, with extra storage for the barrels and bottles. As the company grew, in addition to their original beers, they started making exciting, hop-forward beers, including Elysium, Red Vienna and Maori. Most of the brands are also available in bottles. The brewery moved once more in 2016 to bigger premises, so as to allow the installation of a larger brew kit, while the old site was turned into a dedicated brewery shop.

Concept.

Let's have a look at the popular brands that are still in demand today. Hedge Hopper is a deep golden brew with undertones of malt and a subtle hint of hops, with an ABV of 3.8 per cent. Road Runner is a light pale ale, named after the strange running gait of the pheasant and also with an ABV of 3.8 per cent. Then there is Whirly Bird, a pale amber beer with a fruity, zesty taste and undertones of malt, with an ABV of 4.0 per cent. As a tribute to the Mallory Everest expedition in 1924, a beer entitled 1924 was created in the form of a powerful and fruity amber ale with an ABV of 4.5 per cent. Finally, we have one of the beers from the Black Label range in the form of Concept, which is the first in this range of experimental beers: an IPA with an ABV of 4.7 per cent.

Their very popular stable of beers can now be found in pubs, bars, restaurants and shops throughout Cheshire, Manchester, Lancashire, Staffordshire, North Wales and various other locations throughout the UK.

Wincle Beer Co. Tolls farm Barn, Wincle, Macclesfield

The Wincle Beer Co. was set up in 2008 in a redundant milking parlour on a working farm within the beautiful Peak District National Park. Giles Meadows, the owner, completed a four-month course at the Brewlab in the University of Sunderland in order to prepare himself. Despite this, the intention was only to brew beer for family and friends and to enable him to sit on his veranda whittling wood. In the same year, the first beer rolled out of the brewhouse in the disused milking parlour. Fortunately Giles had plenty of friends willing to critique his product, but this scuppered his plans of a relaxing life in the idyllic location.

The beer was an immediate success and he could not brew it fast enough; one of the beers submitted to the Tamworth Beer Festival resulted in a silver medal. A move to a more suitable location was called for, to somewhere else within this stunning village. They moved to a beautiful stone barn with a new state-of-the-art fifteen-barrel plant in the centre of Wincle and are now brewing flat-out five days a week. Besides Giles, the staff comprise Justin the head brewer, Hayley the shop manager and Leon the delivery chap.

Their brands, whose names are taken from local tradesmen and gentry etc., include Wincle Waller pale ale at 3.8 per cent ABV. This is named after Peter Eardley, one of the few remaining dry-stone wallers. Rambler amber ale at 4.0 per cent ABV is named after another Peter, who enjoys rambling around the Peak District and has written a book on the subject. Then there is Sir Philip premium bitter, with an ABV of 4.2 per cent. This is named after Sir Philip Brocklehurst, who was the squire of the local Swythamley Hall; he was a great adventurer and accompanied Shackleton to the Antarctic. Then there is Burke's Special, an exceptional bitter at ABV of 5 per cent, and named after the Mastiff dog from Swythamley Hall – to quote, 'Faithful as a woman and braver than a man.' Just in time for summer 2006, they introduced a new IPA called Life of Riley, a splendid drink with an ABV of 4.8 per cent. These are just some of the brands that Wincle beer produces in cask and bottle in ever greater quantities to supply their many customers from pubs, clubs, restaurants and personal sales.

And a beer that I have not mentioned is Wibbly Wallaby, a full-bodied ale with an ABV of 4.4 per cent – it has just won a competition, the CAMRA Champion Beer of

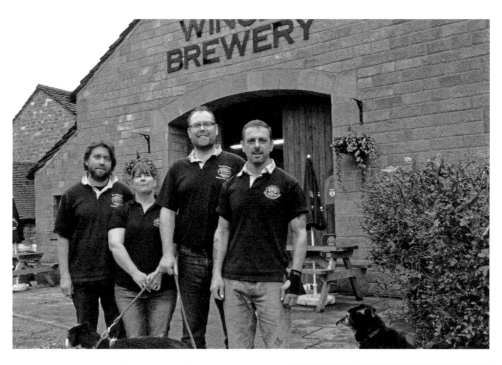

Above: Wincle Brewery team.

Right: Wincle Waller.

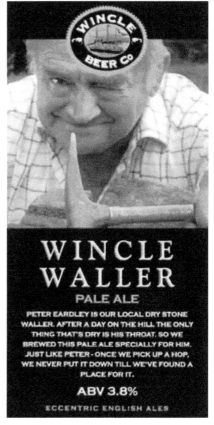

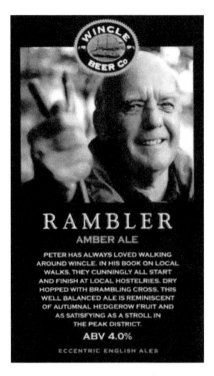

Wincle Rambler.

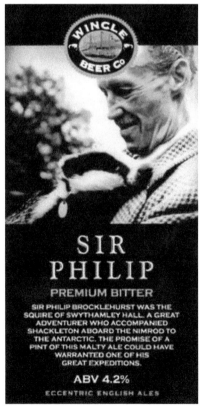

Wincle Sir Philip.

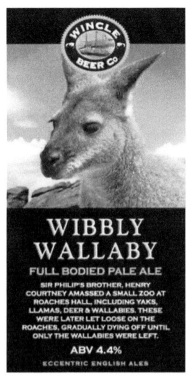

Wibbly Wallaby.

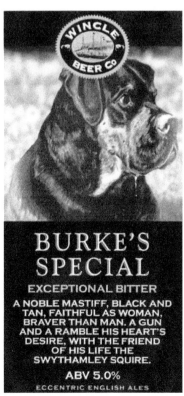

Burke's Special.

Cheshire. Well, this is what the Wincle Brewery announces: 'Hot off the press, we were chuffed to learn that an esteemed panel of judges have named our Wibbly Wallaby as the finest best bitter in all of Cheshire.' Sort of speaks for itself, I suppose.

Storm Brewing Company, 2 Waterside Macclesfield.

In 1998, two partners, Hugh Thompson and David Stebbings, acquired the old ICI boiler house in Hurdsfield in order to set up their new brewery, to be called The Bollin Brewing Co. or 'BBC' for short, and named after the local River Bollin. They started to install the brewing equipment while listening to the local radio, at which time Macclesfield Town football club were being beaten 5-0 by Birmingham City. This knocked the club out of the League Cup and, during the match, they heard the announcer say, 'there's a storm brewing'. Therein is the reason for a name change to the Storm Brewing Company.

For many years the ancient Macclesfield pub the Mechanics Arms served the people of the town; then, just before the last war, 1937 to be exact, it ceased trading. The partners decided that this building, at 2 The Waterside, would be a good location to which to transfer their already quite successful brewery. They acquired the old pub and, in 2001, started to brew their products, renaming it The Storm Brewing Co. Thanks to friends' suggestions, their first two beers were called (g)Ale Force and Beaufort's (sc)Ale. Names of local landmarks followed like Windgather, named after Windgather

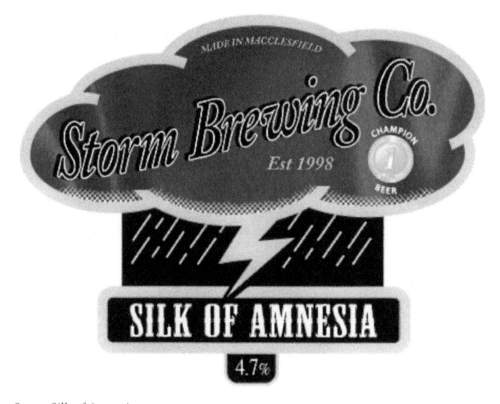

Storm Silk of Amnesia.

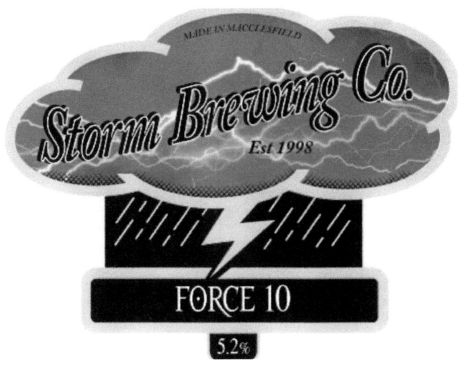

Force 10.

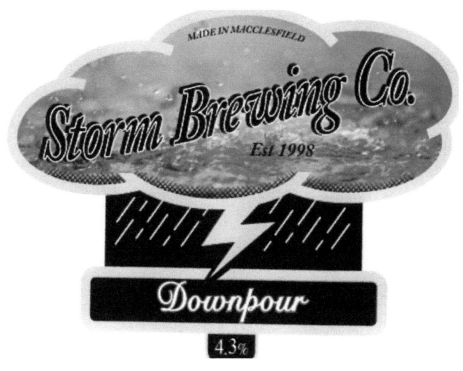

Downpour.

Desert Storm.

Hurricane Hubert.

Rocks and Bosley Cloud. Many other names were allocated to special brews for sports events and special occasions. Hurricane Hubert, for instance, marks Hugh moving to the brewery on a full-time basis. Humour was not far from the naming of their beer. Christmas ale was 'Looks Like Rain Dear', and for the 2006 World Cup, what better name for their German-style brew than 'Bekkembräu', now Pale Gale Ale.

Let us have a look at a few of their beers. Silk of Amnesia is a champion dark beer, with an ABV of 4.7 per cent. Force 10 is a porter-style dark beer, brewed with Fuggles hops; it is rich in chocolate, with a hint of blackberries and liquorice, with an ABV of 5.2 per cent. Downpour is a light, golden bitter with a smooth, fruity hop aroma and an ABV of 4.3 per cent. Desert Storm is a session ale, brewed with crystal and chocolate malts, and Fuggles and Golding hops. The ABV is 3.9 per cent and, finally, Hurricane Hubert, a dark amber celebration ale, with an ABV of 4.5 per cent.

Windgather was Champion Beer of Cheshire in 2000; Ale Force was a finalist in the Tesco Bottled Beer Challenge in 2001; Pale Gale Ale was best IPA/Lager at the Macclesfield Beer Festival in 2008. The list goes on, providing ale for clients large and small, near and far, with the brewery's favourite phrase being, 'Come around to our way of drinking and experience the calm after the Storm'. Brewery visits are popular and a church pulpit has been incorporated into the bar.

Red Willow Brewery Macclesfield

Toby Mckenzie started brewing as a hobby, not with home brew like many blokes but what he calls 'proper brewing'. He found the results quite passable, and decided that there could be a business there as well as a hobby. Like all hobbies of this nature, it

Red Willow Headless.

Red Willow Seamless.

started to take up more and more time, with better and better results. Over a boozy day drinking his own brewed ale with friends, it was decided to turn the hobby into a full-blown business, a name was sought and he came up with Red Willow Brewery, based on their children's middle names.

Toby persuaded his wife Caroline that it would make good sense to set up their own microbrewery; in 2010, they decided to give it a go, eventually setting up their own brewery in Byron's Lane, Macclesfield – in The Lodge, Sutton Garrison, to be exact. The overriding objective was to brew beers that they themselves wanted to drink with passion and without compromise.

This hobby has now turned into an extremely successful venture, and their brewery supplies literally hundreds of pubs from Scarborough to London. In 2011, early in the venture, their Wreckless Pale Ale was voted Champion Beer of Cheshire. In the typical Red Willow description, it was described as 'An Award Winning Orchestrated Cacophony of Hops and Malt'. This beer also won a SIBA gold medal.

The brewery's core beers are Seamless, a pale ale with an ABV of 3.6 per cent; Mirthless pale ale with an ABV of 3.9 per cent; Headless with an ABV of 3.9 per cent, described as light hoppy and refreshingly honest; Feckless, a classic British bitter with an ABV of 4.1 per cent; Directionless, a golden bitter with an ABV of 4.2 per cent; Ageless, a strong beer described as 'big on hops' and 'big on flavour', with an ABV of 7.2 per cent; and Wreckless with an ABV of 4.8 per cent, the Champion Beer of Cheshire winner. Finally, there is Smokeless – dark, velvet, smooth and intriguingly smoky, with an ABV of 5.7 per cent. All of the beers are also available in cask and keg.

Red Willow Feckless.

Red Willow Directionless.

The Bollington Brewery

Was first owned by Parrot and Horsfield from 1877. By 1898 Heaver Brothers, a limited company from 1931, were the brewers on the site and they in turn were acquired by Ind Coope and Allsopp Limited in 1934, brewing ceased on the site in 1938.

Handforth Brewery Company, Handforth

Closed 1908.

North Cheshire Brewery Co. Ltd, Macclesfield, Charles Street

Thomas S. Bromley founded the brewery in 1862 and liquidated it in 1867 as the Macclesfield Brewery and Wine Company. It traded as The Macclesfield Brewery Company Ltd from 1869 to 1873; there were later name changes until it was taken over by Lonsdale & Adshead Ltd in 1928. They took over the management and sold the brewery but kept the company as a subsidiary. Acquired by Ind Coope & Allsop in 1950 at the same time as Lonsdale & Adshead, it went into liquidation in 1960.

Queens Brewery, Albert Place, Macclesfield

Owned by F. W. Maurice & Company and closed in 1905.

Crown Brewery, Bond Street, Macclesfield

Owned by W. A. Smith & Sons, and taken over by Marston, Thompson and Evershed in 1962 with about twenty tied houses.

Sutton Brewery, Byrons Lane, Macclesfield

Registered in 1897 to acquire the business of Stanicliffe Brothers of Mirfield and Macclesfield. It was taken over by Lonsdale and Adshead in 1920.

The Macclesfield Brewery

Lonsdale & Adshead Limited was a brewing firm at the Macclesfield Brewery, 45 Park Green, Macclesfield. Brewing had taken place there since 1790. In 1919 the company acquired Stancliffe Breweries Ltd, Sutton Brewery, Macclesfield, together with forty licensed houses. In 1928 they acquired North Cheshire Brewery Limited and their premises in Park Street Macclesfield. In 1950 the brewery became part of the Ind Coope & Allsop Ltd brewing company and brewing ceased in August 1950. Soon after the building was sold to Whitbread & Co Limited.

Macclesfield Star Brewery, Bond Street

Owned by Harry Evans & Co. Sold to Bindley & Co of Burton on Trent in 1890.

Macclesfield Grapes Brewery, Lord Street.

Owned by C. A. Hordern & Co. Taken over by the North Cheshire Brewery Company around 1910.

Breweries Closed and Operational in South Cheshire

Merlin's Micro Brewery, Arclid, near Sandbach

In September 2010 Sue and David Peart, set up the Merlin Brewing Company. They built their family-run business on a farm at Arclid in the beautiful Cheshire countryside, aiming to make it as environmentally friendly as possible. In this they have succeeded, and they believe they may have the most eco-friendly brewery in the country. They have done this by using only renewable energy, generated by an array of solar panels and a wind turbine; so, in addition to the good taste, the feel-good factor exists when drinking Merlin ales.

Their success was quick in coming, and they used as a theme for their brewery the legend of King Arthur and his Round Table. This allowed them to conjure up such names as Excalibur, Merlin's Gold, The Wizard, Dark Magic and Dragon Slayer, to name but a few. Recently Merlin's Gold was named Champion Beer of Cheshire by CAMRA.

Let us have a look at the four beers shown below. First the champion, Merlin's Gold, made with German and American hops, is a delicious golden ale with an ABV of 3.8 per cent. Dragon Slayer is a strong, dark copper ale, made with the finest Maris Otter and chocolate malt, with blackcurrant and lemon after notes. This ale has an ABV of 5.6 per cent. The Wizard is light amber in colour; this time American and New Zealand hops are used to make a beer with a taste and aroma that leaves you wanting more. Its ABV is 4.2 per cent. Finally, in our list of four examples out of the eleven beers that are permanently available, we come to Excalibur, where we find a well-balanced, straw-coloured ale with a hint of sweetness. The malt and hops from four countries are carefully blended to create this popular ale. Its ABV is 3.9 per cent.

The business is growing in popularity, and currently produces up to 100 9-gallon casks of hand-crafted ale each week, with which they supply outlets within a 30-mile radius of the brewery. David and Sue are fastidious about the quality of their ale and go to great lengths to ensure each and every pint is as consistent as the last. Their strap line, 'brewed for a magical taste', certainly rings true every time.

Above: The logo.

Left: Merlin's Gold – pump clip.

Front Row Brewing, Congleton

Nick Calvert had a thriving business of textile printing in his home town of Congleton and, being an ex-rugby player for Congleton, Sandbach and Glossop, he knew his way around the enjoyment of beer! In 2012, Nick decided to set up his own artisan brewing company, committed to making hand-crafted beers, using innovative techniques in his brand-new and modern small brewery. His love of the game of rugby came to the fore and influenced all things, from the name of the company, 'Front Row Brewing', to the names of the beers. Let us look at a few: Lohag seems a strange name but it means 'Land of Hops And Glory'. It is a hoppy pale ale with an ABV of 3.8 per cent. Collapsed is a strong IPA with an ABV of 5.6 per cent. Pause is a chocolate stout with an ABV of 4.5 per cent, while Crouch is an easy drinking and traditional English bitter with an ABV of just 3.8 per cent. Rucked is a strong bitter with an ABV of 5.2 per cent.

They had their first outing at the Macclesfield Beer Festival in May 2012 and, by the end of the night, the beers had sold out. The positive reaction meant that the business

Front Row Brewing.

FRB Lohag.

FRB Collapsed.

FRB Pause.

FRB Crouch.

started to grow in the North West. The name 'Front Row' became well known and respected in Real Ale circles. The brands began to find their way into pubs, restaurants and specialist beer shops. The business has now been selected by wholesalers to distribute the products nationally; for this small brewery, it is onwards and upwards.

I will use the excellent website of the Front Row Brewery to lead the reader through the art of brewing.

> Front Row uses the classic traditional English brewing method with the arrangement of tanks being: hot liquor tank, mash tun, kettle and fermenting vessels. A 1400 litre batch can be produced in any one brew. The malt is carefully added to the hot water in the mash tun, where it is left for ninety minutes to release all the sugars from the malt. Then the wort is transferred to the copper where it is brought to the boil, once boiling the bittering hops are added. After an hour the flavour hops are introduced and the wort is left for a short time to absorb the flavours. It is then cooled and transferred to the fermenting vessel where the yeast is added. In a few days the beer is ready to be transferred into barrels where is it left to mature for two weeks before being delivered to customers. Only the finest English Malts and predominantly English hops supplemented with hops from the USA, Australia, New Zealand, Germany and Slovenia.

So there we have it, micro brewing at its best. In 2014 Front Row Brewery's Pause received a bronze medal in the SIBA Regional Winner competition for Speciality Beers. The following year, 2015, Rucked won a silver medal in the strong bitters and pale ales category in the same competition.

Manning Brothers Brewery, Congleton

Another very popular micro-brewery in the South Cheshire area is that of Manning Brewers. Set up quite recently in 2015 at Lower Overton Farm, located in the beautiful Cheshire countryside, is a company dedicated to the brewing of fine ale, using the finest ingredients and British hops. This is a statement often repeated in this book, perhaps because it is an important aspect of micro-brewing.

Manning Brewers, however, have another ace card: qualifications. It is a family-run business and the brewmaster is Dave, who has thirty years of experience in various multinational companies and accordingly ensures that consistency and quality is present in every barrel. His sons Mike and Joe assist him and call upon their combined twenty years' experience in owning and running real ale pubs; they are well versed in what the customer wants from a good pint. Among their academic qualifications you will find a rather important one in biochemistry.

Their mother Mandy is an ex-teacher and company secretary, and is said to be the person who really runs the business. Finally, at the important end is the man who is responsible for publicity and organisation, Michael Potts. He may not be exactly one of the family but his first-class degree in brand management is not to be sniffed at. He has plenty of experience working with some of the major blue-chip brands. They class themselves as an odd bunch, but a very efficient one.

Manning Brothers logo.

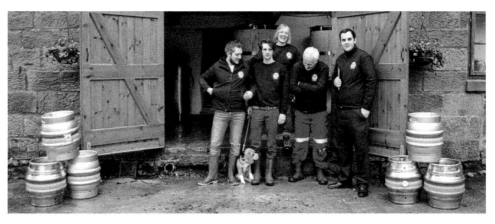

Manning Brothers staff.

Man Up.

Whoa Man.

Cave Man.

Their main brands are Man Up at 4.0 per cent ABV, a perfect dinner ale; Cave Man at 4.2 per cent ABV, a good, no-nonsense ale; and Woah Man, 3.8 per cent ABV, a flavoursome session beer. The company delivers to many pubs, clubs and shops in the South and Mid Cheshire areas.

Cheshire Brewhouse, Daneside Business Park, Congleton

Shane Swindells has twenty years' experience in food manufacturing and brewing. Also having experience as an engineer, he decided to build a brewing plant for himself; this he did, without, like some, using off-the-peg equipment.

The idea of starting the Cheshire Brewhouse had been a plan of Shane's for a long time. He was brought up the son of a publican and has been around beer all of his life. Back in the 1980s he tinkered with brewing his own beers and wines, but the purchased kits just did not meet his requirements. The interest waned and he spent his time tasting other brewers' products! In 2007 he got a job as an engineer with the aforementioned Molson Coors brewery at Burton upon Trent. This reignited his interest in brewing cask ales, and he took the opportunity to learn all that he could about the mysterious world of the brewing process. He listened, read and studied the art of making the best quality cask ales and, when this was done, he built his own small brewery.

Using a 1Brewers Barrel Brew Length, Shane started to brew his own beer in his garage for a number of years before starting the commercial brewery.

Cheshire Brewhouse logo.

Cheshire Gap.

Cheshire Set.

DBA.

Engine Vein.

Lindow 'The Black Lake'.

He then built a 5BBL plant with four fermentation vessels in May 2012, but soon found this wasn't big enough to keep up with demand. The unit adjacent to the brewery became available in 2014, and so Shane Built a new 10BBL Brewhouse with four fermentation vessels and conditioning tanks, while brewing on the 5BBL kit. The 5BBL kit was then sold in parts, and the tanks now resides at Trinity Brewing in Wakefield, Blackjack, in Manchester & Shiny Brewery in Derby.

Currently the Cheshire Brewhouse have eight core beers. Cheshire Pride is a 3.6 per cent ABV Traditional English Bitter, while Cheshire Gap is a light English Pale Ale with an ABV of 3.8 per cent. Cheshire Set is a young, vibrant and blonde ale with an ABV of 4.0 per cent. *DBA* is a chestnut strong English bitter with an ABV of 4.6 per cent. Bluesbreaker is a 4.8 per cent ABV American pale ale; Engine Vein is an iconic and traditional best bitter, named after a copper mine at Alderley Edge, with an ABV of 4.2 per cent; Lindow – The Black Lake is a lighter take on Cheshire stout with an ABV of 4.5 per cent. Dane'ish Craft Cheshire *Lager* at 5.6 per cent is all British hopped and brewed on the banks of the River Dane, as are all their beers, and made with water sourced from the river at Rushton Spencer.

The Bear Town Brewery
This brewery is also based in Congleton.

Offbeat Brewery. Units 4–6, Thomas Street, Crewe.
Looking now at a small brewery in Crewe called the Offbeat Brewery, it was established in November 2010 by Michelle Shipman, formerly of the Windie Goat Brewery at the

Disfunctional Functional.

Outlandish Pale.

Out of Step.

Failford Inn, Ayrshire. Recently, Michelle made the decision to sell the six-barrel kit. As this was going through, she was offered an exchange for a two-barrel kit, which she accepted. The brewery will continue to supply their customers from across Cheshire. There are also plans afoot to open as a brewery tap, where customers can sit and have a drink as the beer is brewed in the same room. They will be able to enjoy the ambience and smells commensurate with brewing.

The Offbeat Brewery also appears at events with their wood-burning pizza oven to complement their ale. The brands, the labels of which are very vibrant and include the words 'Brewed by a Chick', meaning Michelle, include: Disfunctional Functional IPA with an ABV of 4.8 per cent; Outlandish Pale with an ABV of 3.9 per cent; Out of Step, a strong IPA with an ABV of 5.8 per cent; and Kookie Gold, with an ABV of 4.1 per cent. There are also many seasonal beers, including Wild Blackberry Mild at 3.8 per cent ABV. A small brewery but perfectly formed.

GoodAll's Brewery, Alsager
A small brewery on the Cheshire/Staffordshire border, which was established in 2010 at The Lodge, where they started brewing using a 2.5-barrel plant. A selection of their ales include: GoodAll's Citra Harp, a blonde beer with an ABV of 4.2 per cent; GoodAlls Freight, a bitter with an ABV of 4.8 per cent; and GoodAlls Big Al, another blonde beer with an ABV of 5.0 per cent.

Woolfs South Cheshire Brewery, Crewe.
Edward S. Woolfe established the brewery in Wistaston Road in 1871. In 1923 Woolfs Limited leased and then sold the company with forty-two licensed houses to Ind Coope & Co.

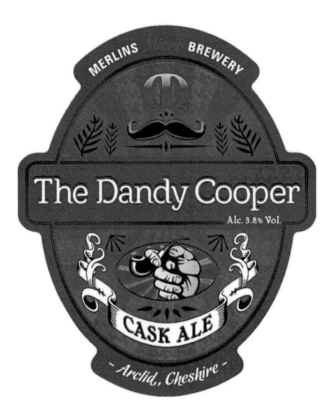

Dandy Cooper.

Dirty Daniel.

About the Author

Paul Hurley is a freelance writer, author and is a member of the Society of Authors. He has a novel, a column in the *Mid-Cheshire Independent* newspaper, other newspaper and magazine credits and a Facebook group entitled *Northwich and Mid Cheshire Through Time* that all are welcome to join. Paul lives in Winsford, Cheshire, with his wife Rose. He has two sons and two daughters.

www.paul-hurley.co.uk

hurleyp1@sky.com

Books by Paul Hurley

Fiction

Waffen SS Britain

Non-Fiction

Middlewich (with Brian Curzon)
Northwich Through Time
Winsford Through Time
Villages of Mid Cheshire Through Time
Frodsham and Helsby Through Time
Nantwich Through Time
Chester Through Time (with Len Morgan)
Middlewich & Holmes Chapel Through Time
Sandbach, Wheelock & District Through Time
Knutsford Through Time
Macclesfield Through Time
Cheshire Through Time
Northwich, Winsford & Middlewich Through Time
Chester in the 1950s
Chester in the 1960s

Villages of Mid Cheshire Through Time revisited
Chester Pubs (with Len Morgan)
Macclesfield History Tour
Chester History Tour
Northwich Through the Ages.